All Things Bright & Beautiful

COLORING *the* CHRISTIAN HYMN

Words by CECIL FRANCES ALEXANDER

Illustrated by MARGARET KIMBALL

Get Creative 6

New York

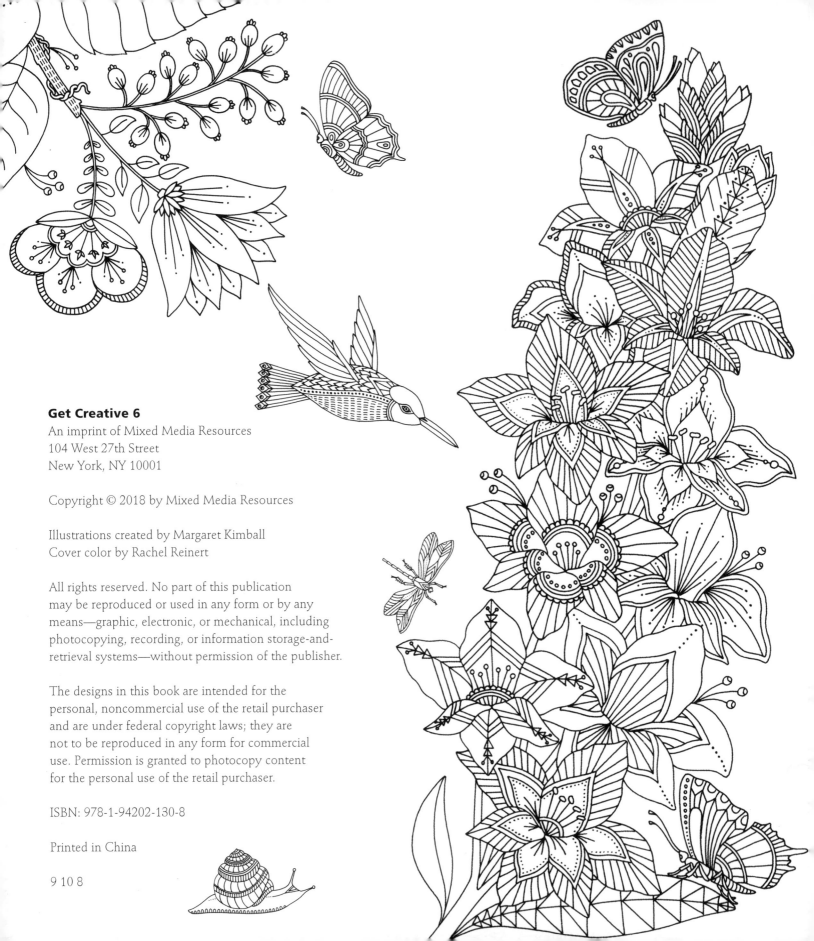

Get Creative 6
An imprint of Mixed Media Resources
104 West 27th Street
New York, NY 10001

Copyright © 2018 by Mixed Media Resources

Illustrations created by Margaret Kimball
Cover color by Rachel Reinert

ISBN: 978-1-94202-130-8

Printed in China

9 10 8

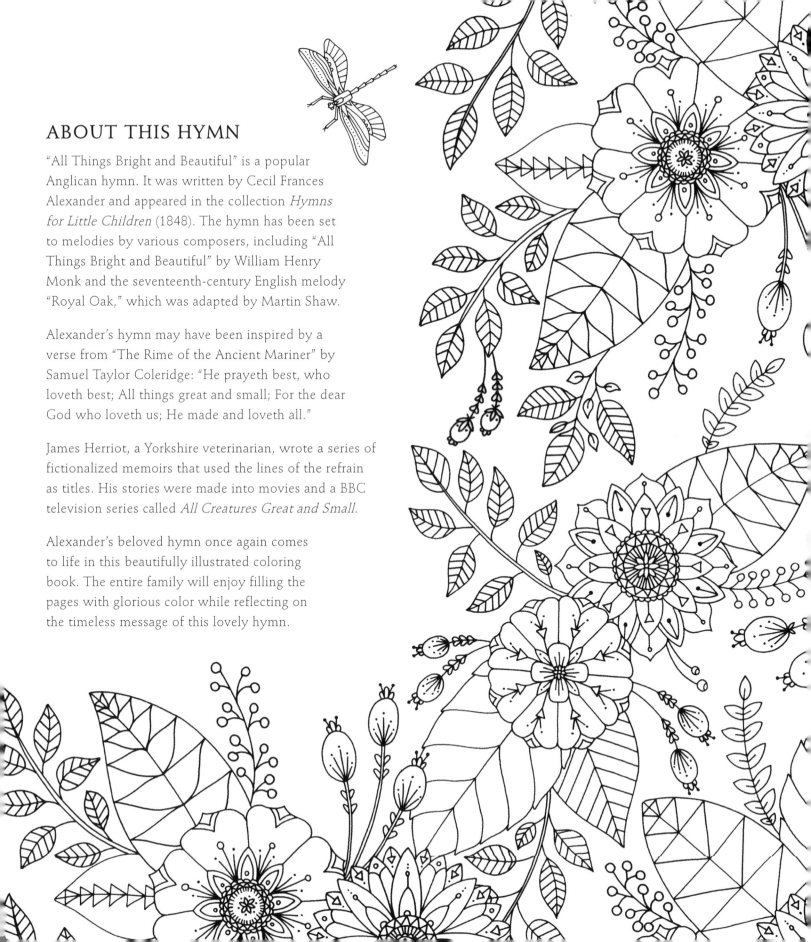

ABOUT THIS HYMN

"All Things Bright and Beautiful" is a popular Anglican hymn. It was written by Cecil Frances Alexander and appeared in the collection *Hymns for Little Children* (1848). The hymn has been set to melodies by various composers, including "All Things Bright and Beautiful" by William Henry Monk and the seventeenth-century English melody "Royal Oak," which was adapted by Martin Shaw.

Alexander's hymn may have been inspired by a verse from "The Rime of the Ancient Mariner" by Samuel Taylor Coleridge: "He prayeth best, who loveth best; All things great and small; For the dear God who loveth us; He made and loveth all."

James Herriot, a Yorkshire veterinarian, wrote a series of fictionalized memoirs that used the lines of the refrain as titles. His stories were made into movies and a BBC television series called *All Creatures Great and Small*.

Alexander's beloved hymn once again comes to life in this beautifully illustrated coloring book. The entire family will enjoy filling the pages with glorious color while reflecting on the timeless message of this lovely hymn.

All Things Bright and Beautiful

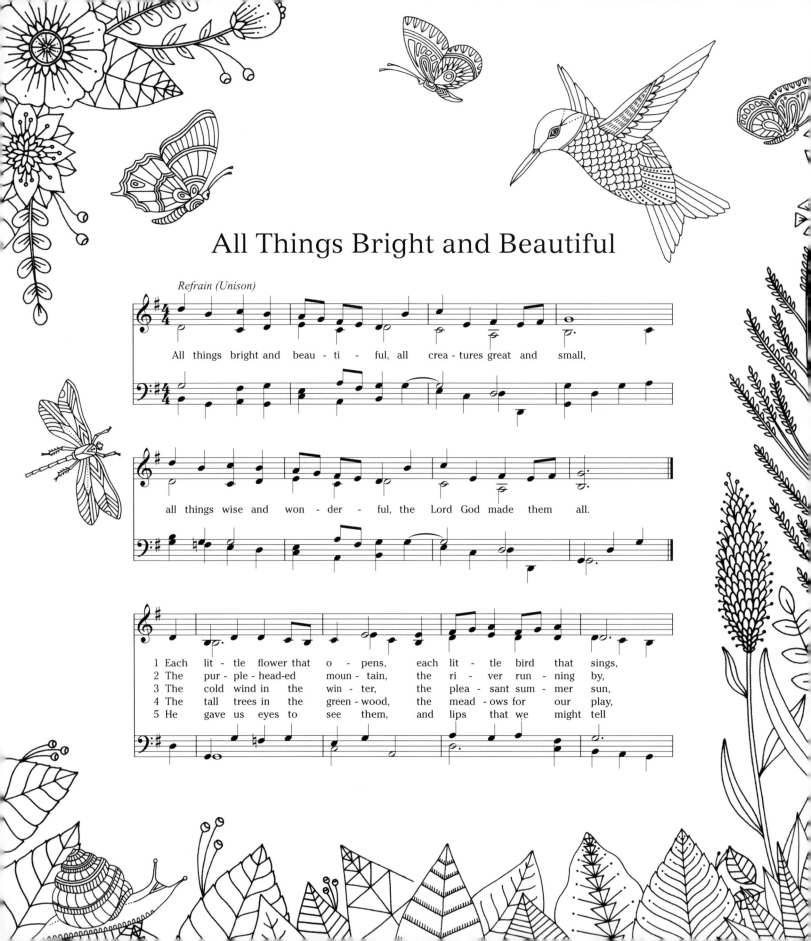

Refrain (Unison)

All things bright and beau - ti - ful, all crea - tures great and small,

all things wise and won - der - ful, the Lord God made them all.

1 Each lit - tle flower that o - pens, each lit - tle bird that sings,
2 The pur - ple - head-ed moun - tain, the ri - ver run - ning by,
3 The cold wind in the win - ter, the plea - sant sum - mer sun,
4 The tall trees in the green - wood, the mead - ows for our play,
5 He gave us eyes to see them, and lips that we might tell

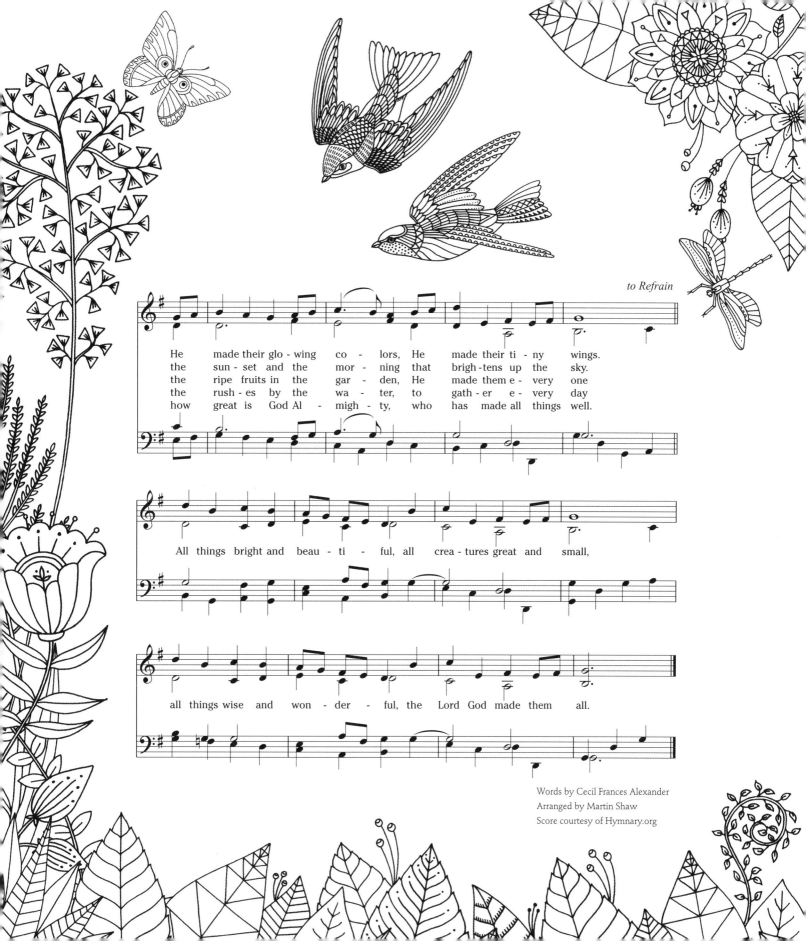

to Refrain

He made their glo-wing co-lors, He made their ti-ny wings.
the sun-set and the mor-ning that brigh-tens up the sky.
the ripe fruits in the gar-den, He made them e-very one
the rush-es by the wa-ter, to gath-er e-very day
how great is God Al-migh-ty, who has made all things well.

All things bright and beau-ti-ful, all crea-tures great and small,

all things wise and won-der-ful, the Lord God made them all.

Words by Cecil Frances Alexander
Arranged by Martin Shaw
Score courtesy of Hymnary.org

All things
bright and beautiful,

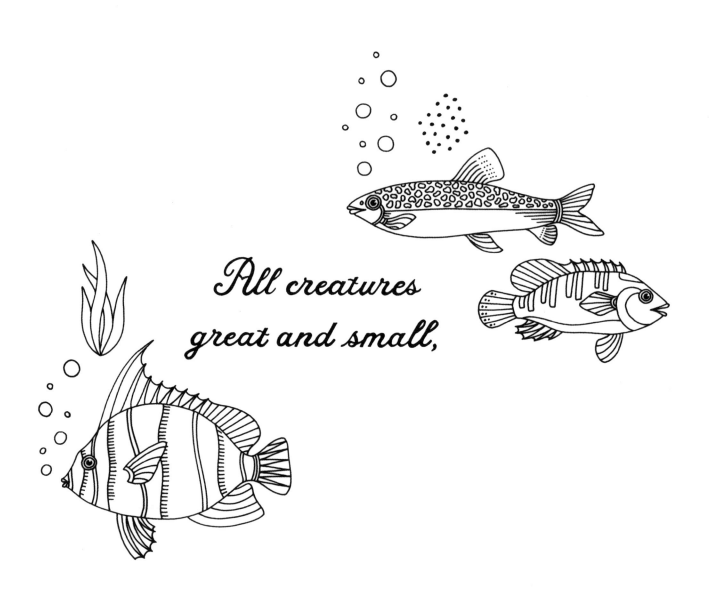

All creatures
great and small,

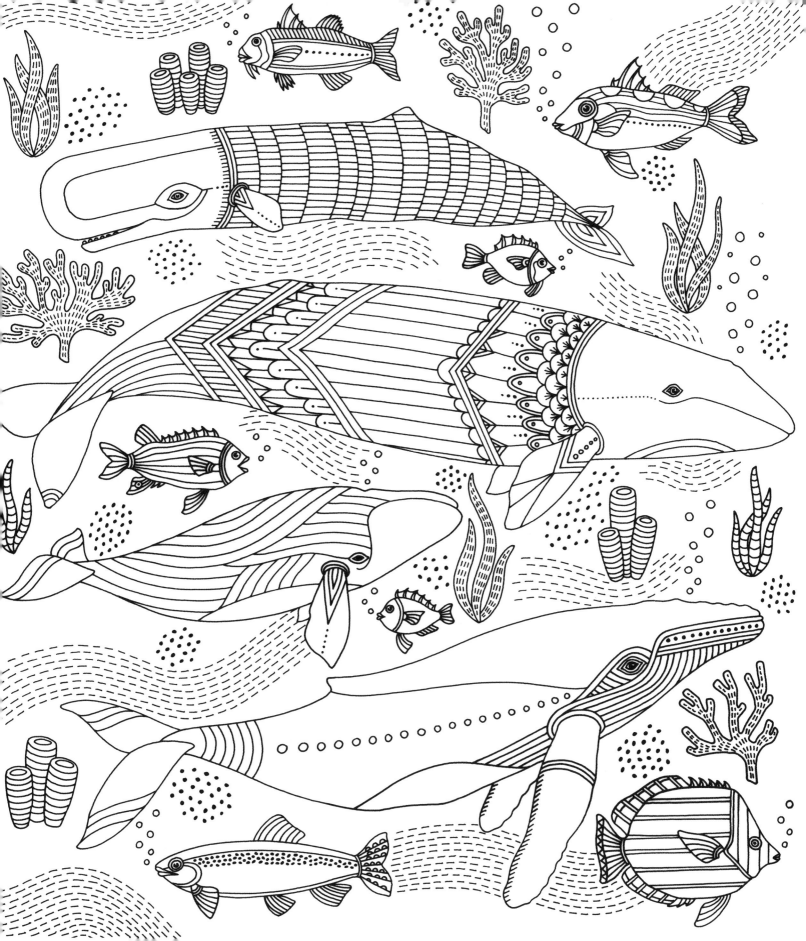

All things

wise and wonderful,

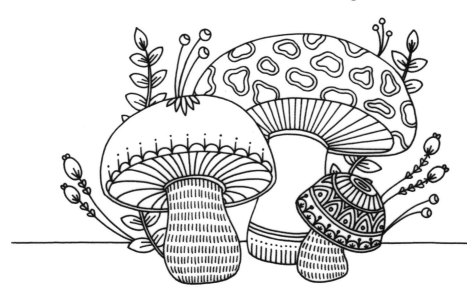

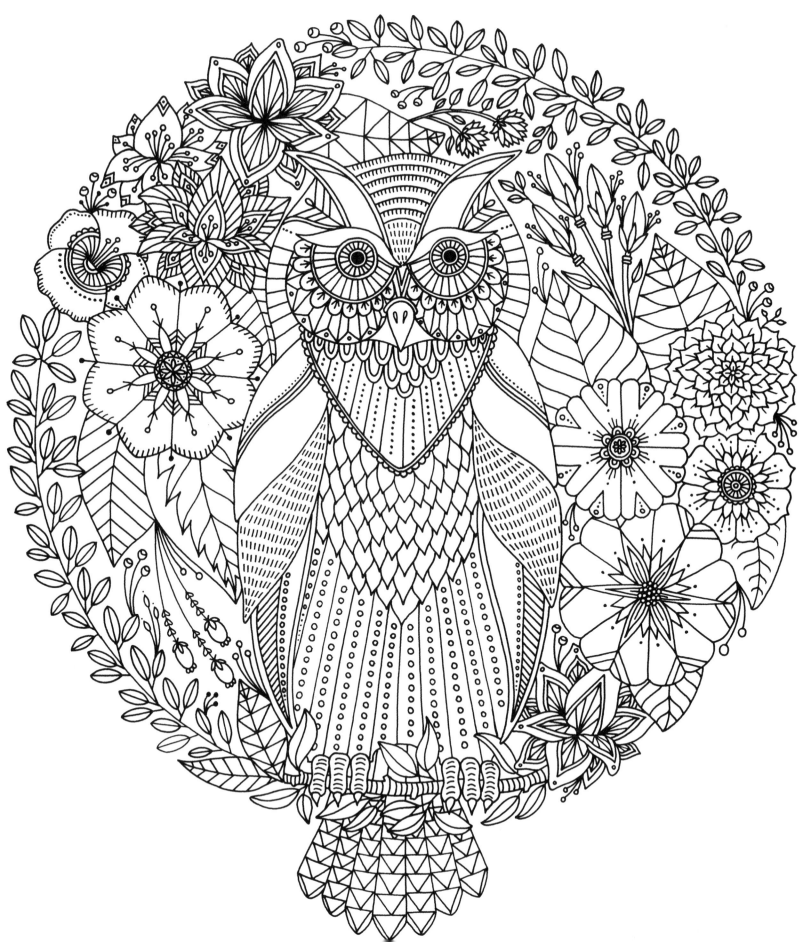

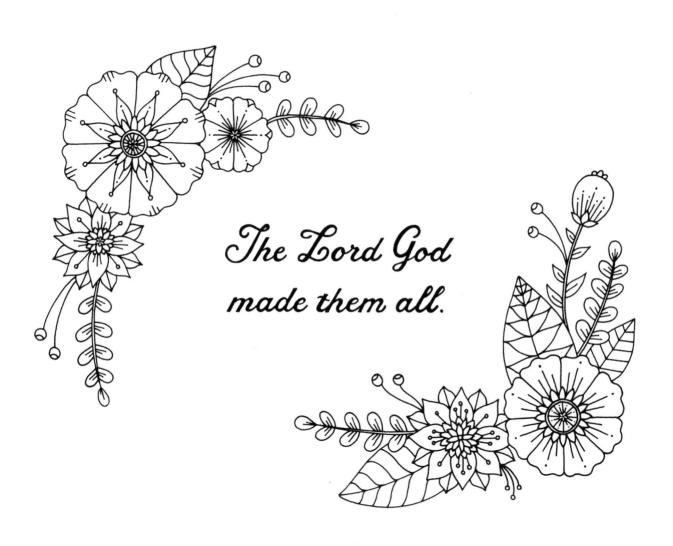

The Lord God
made them all.

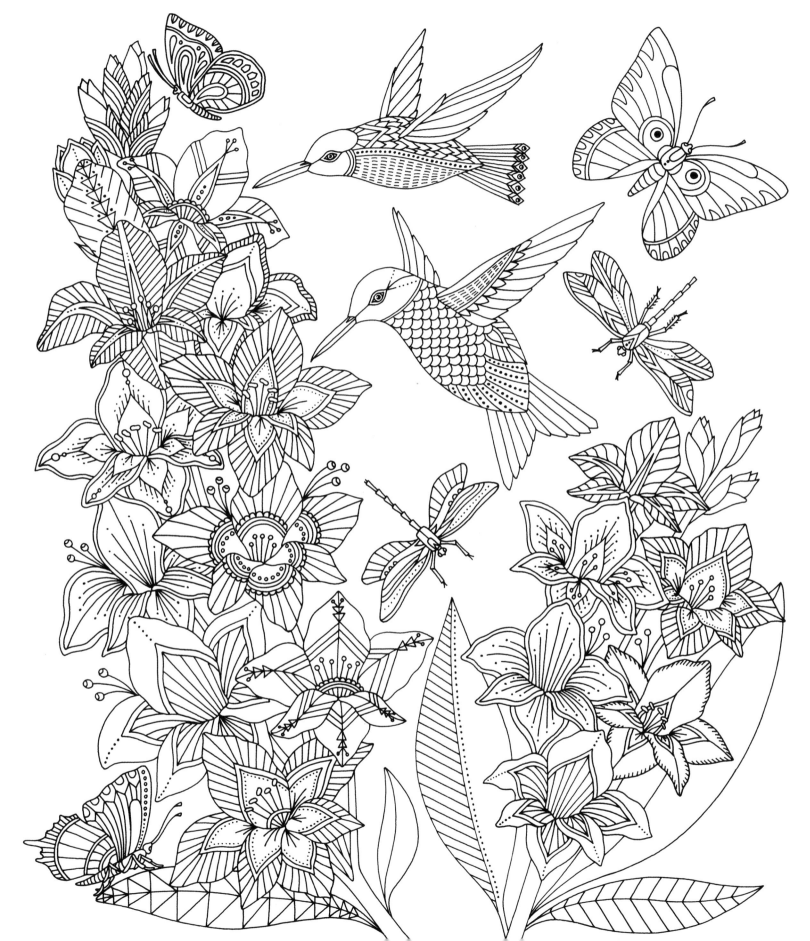

Each little flower that opens,

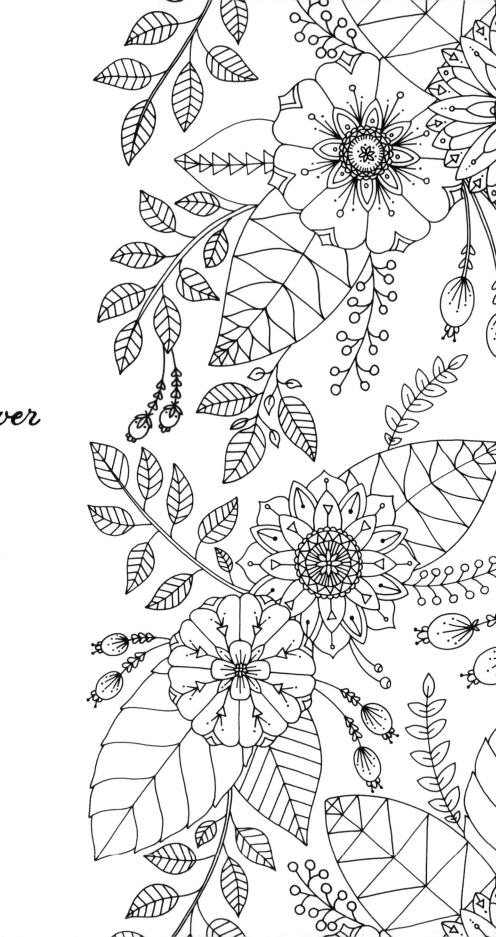

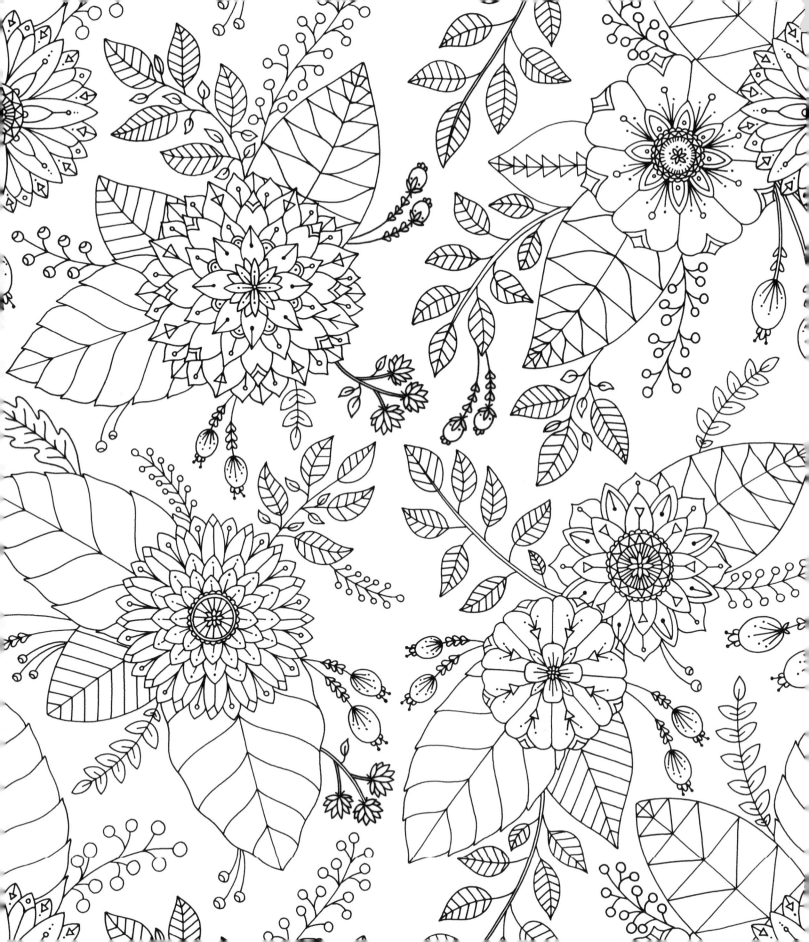

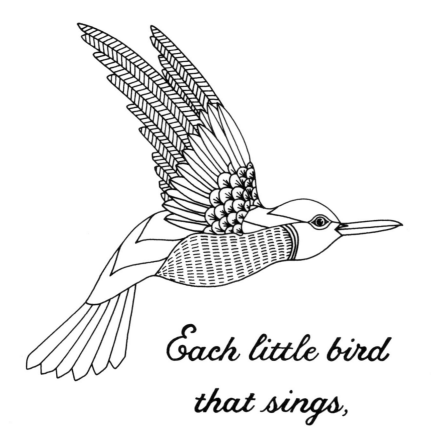

Each little bird
that sings,

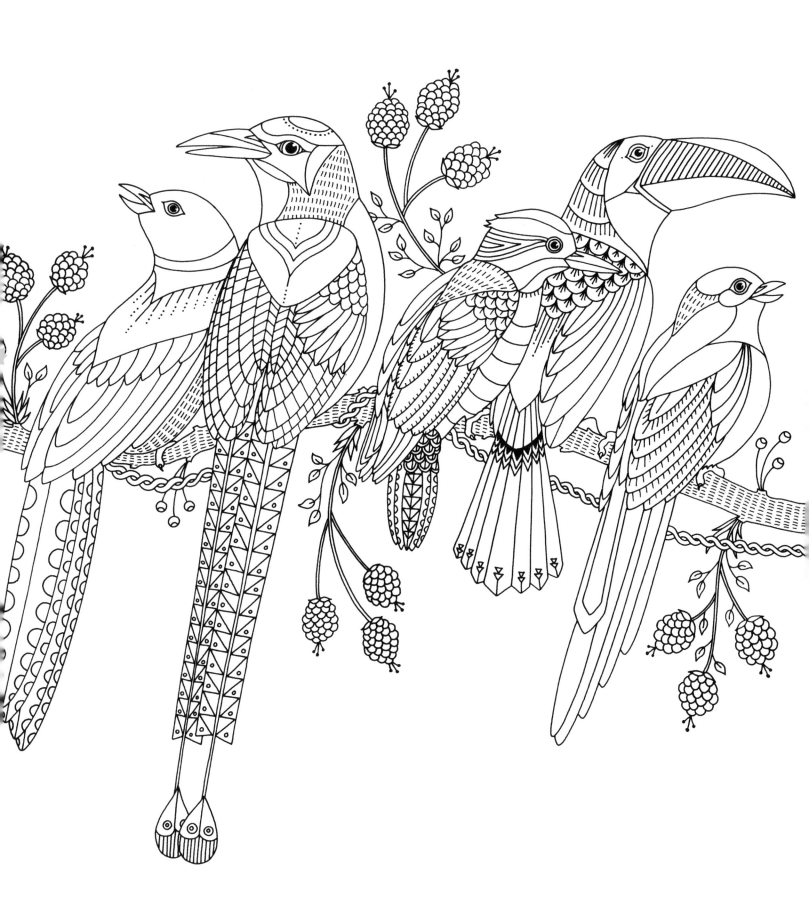

He made their glowing colors,

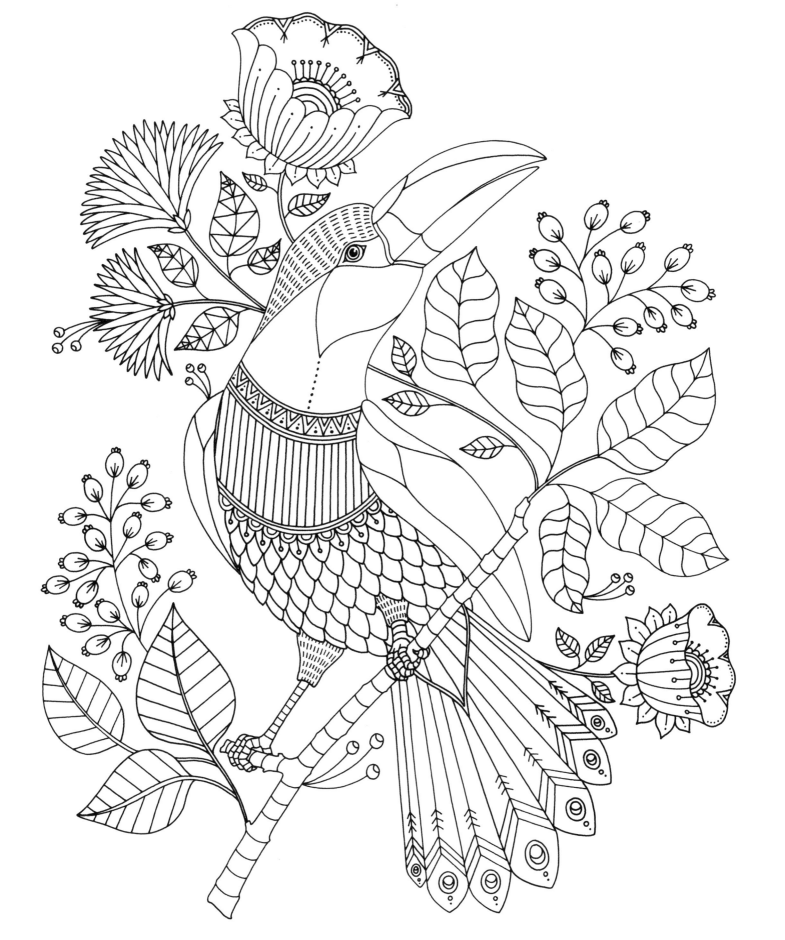

He made their
tiny wings.

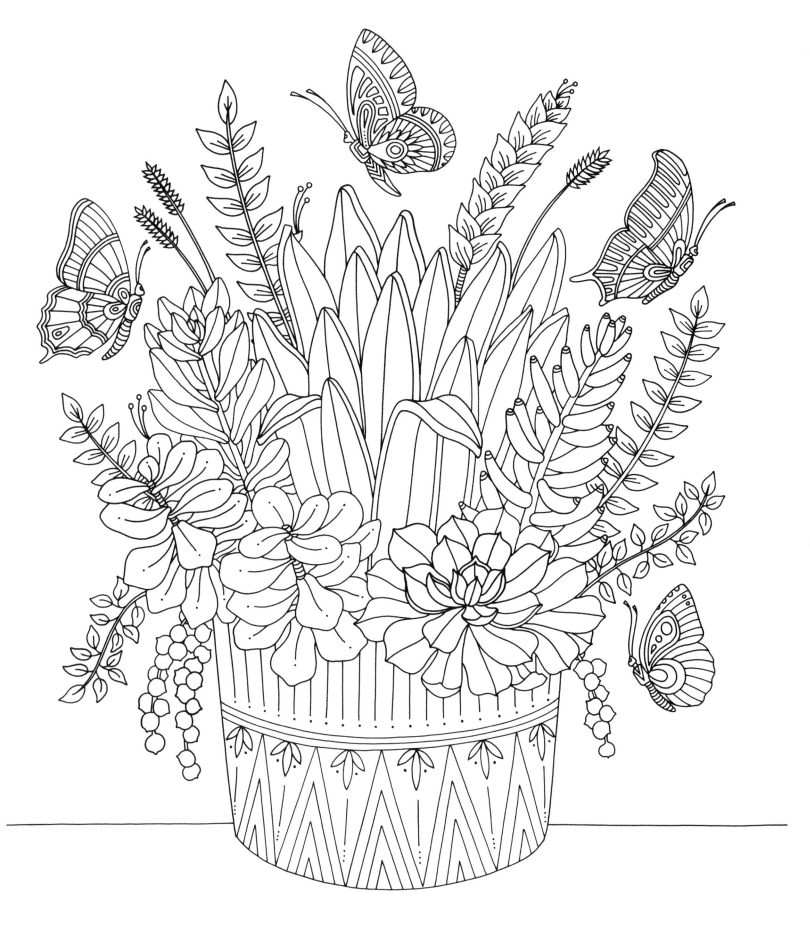

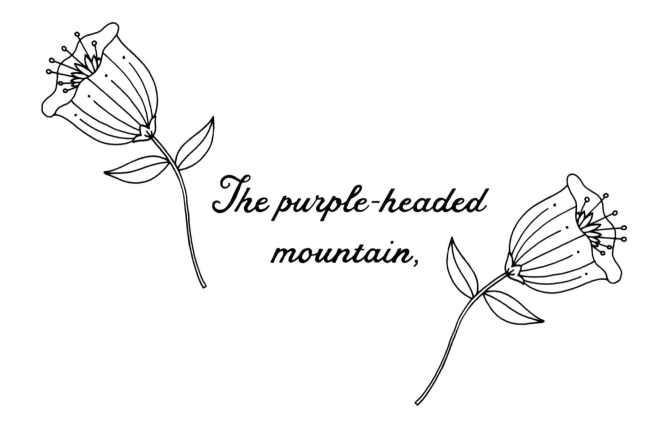

The purple-headed

mountain,

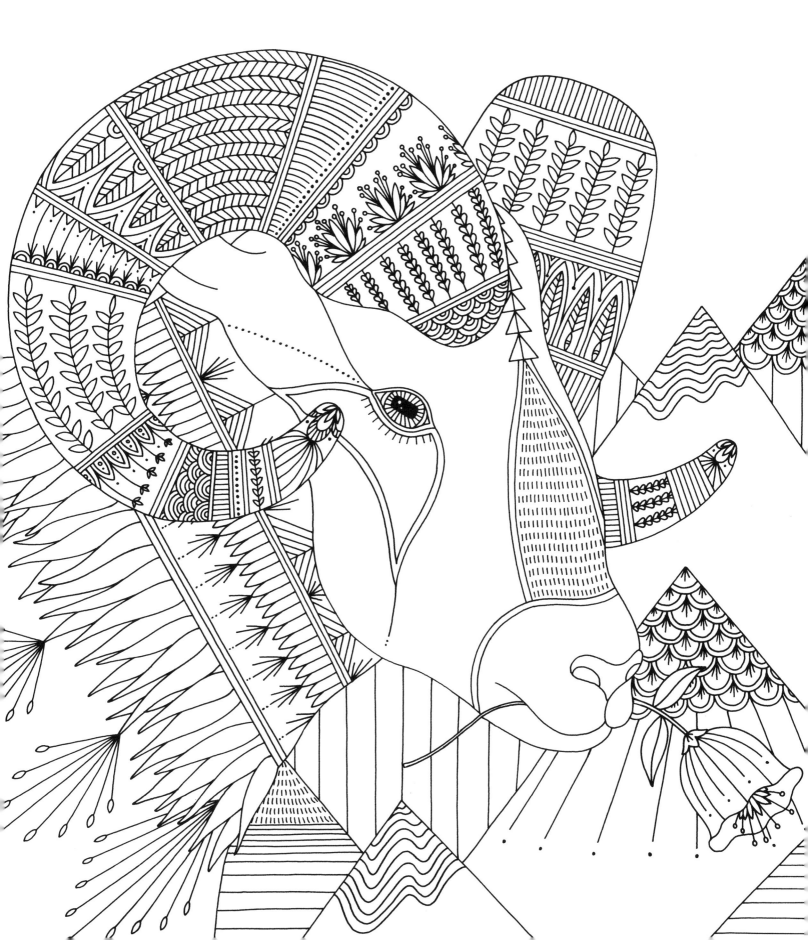

The river
running by,

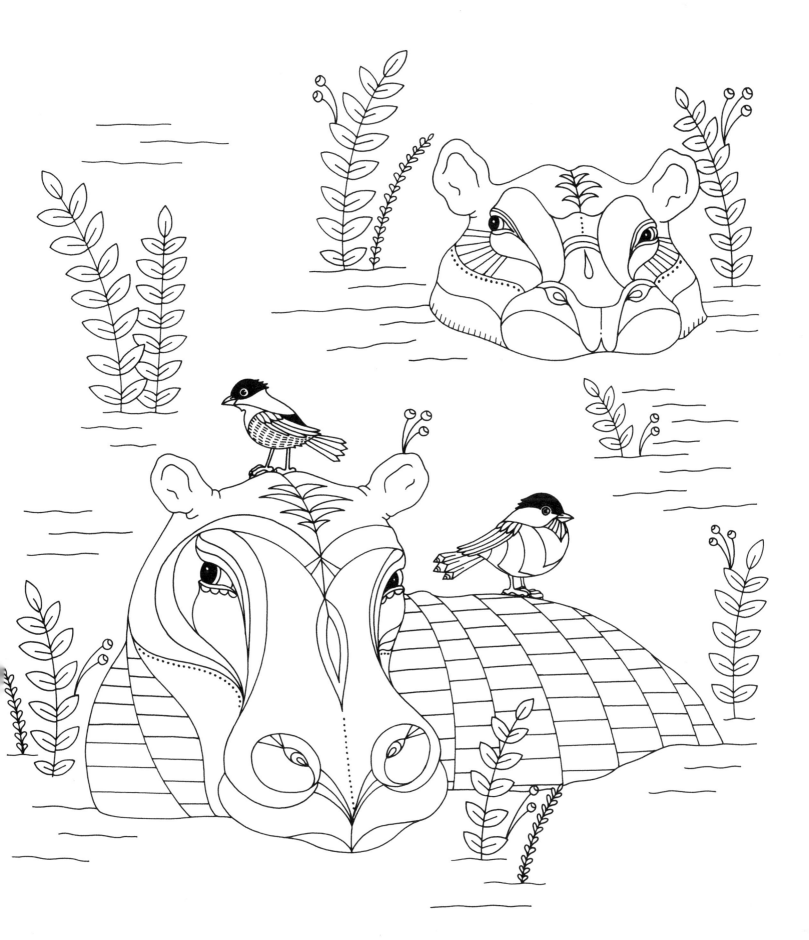

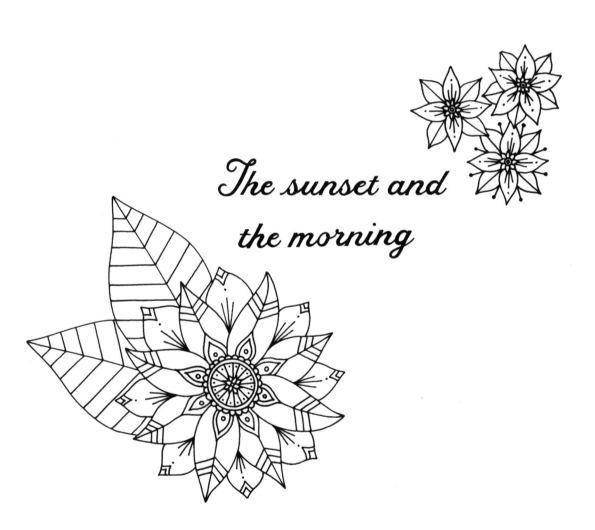

The sunset and

the morning

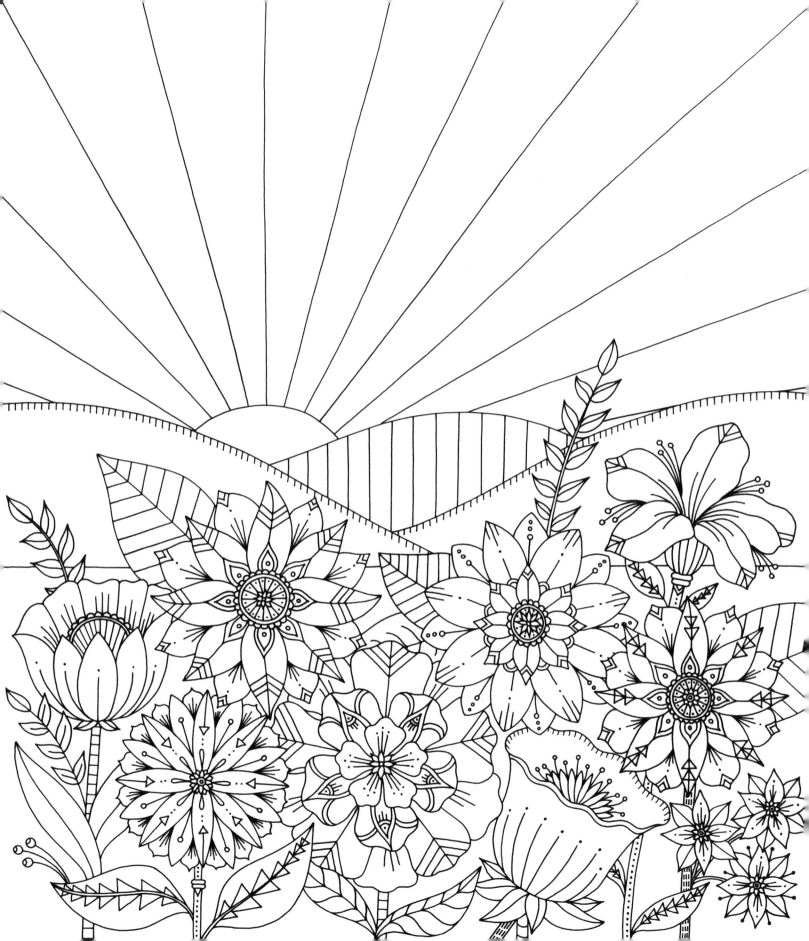

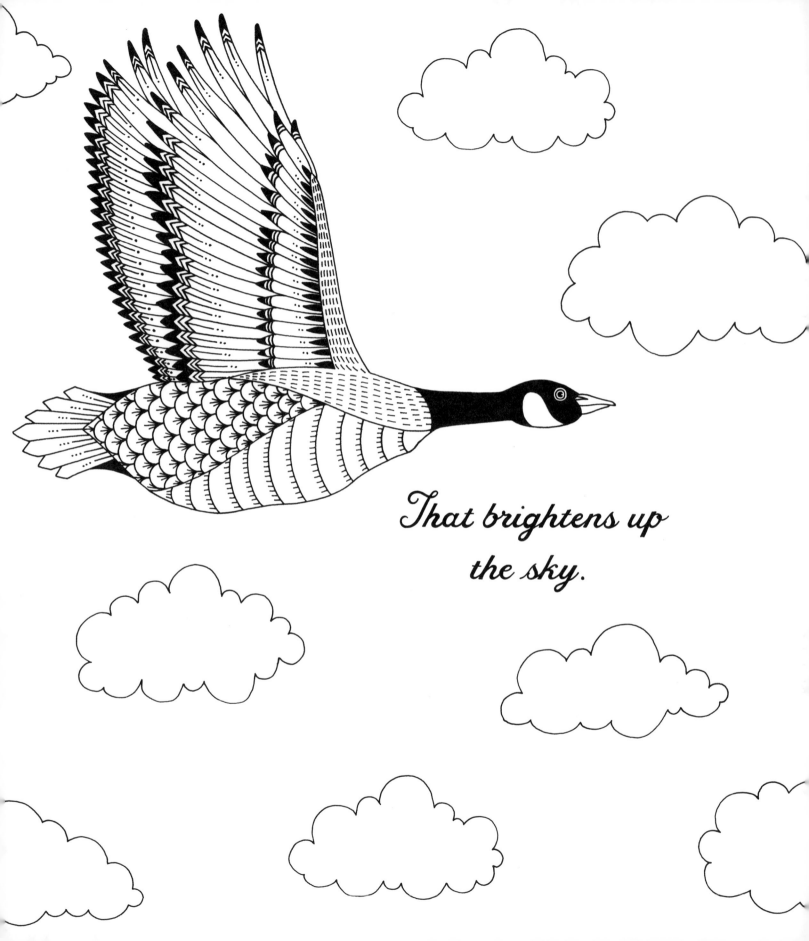

*That brightens up
the sky.*

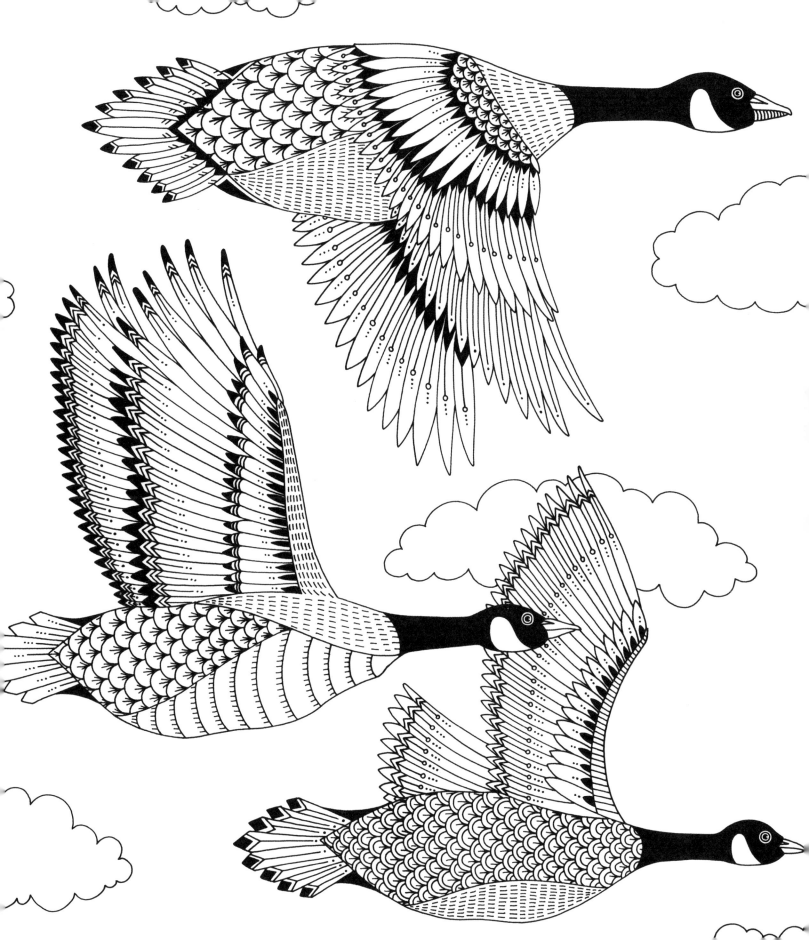

The cold wind
in the winter,

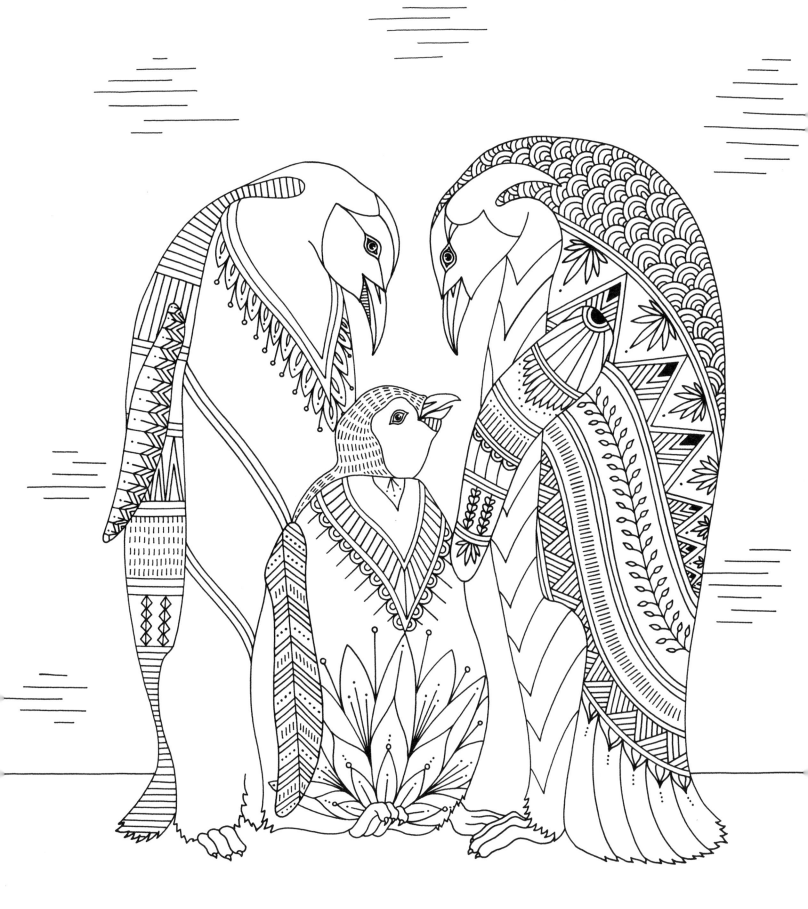

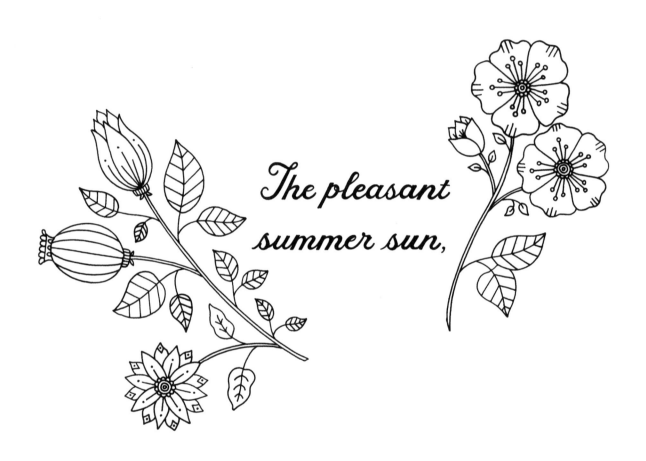

The pleasant
summer sun,

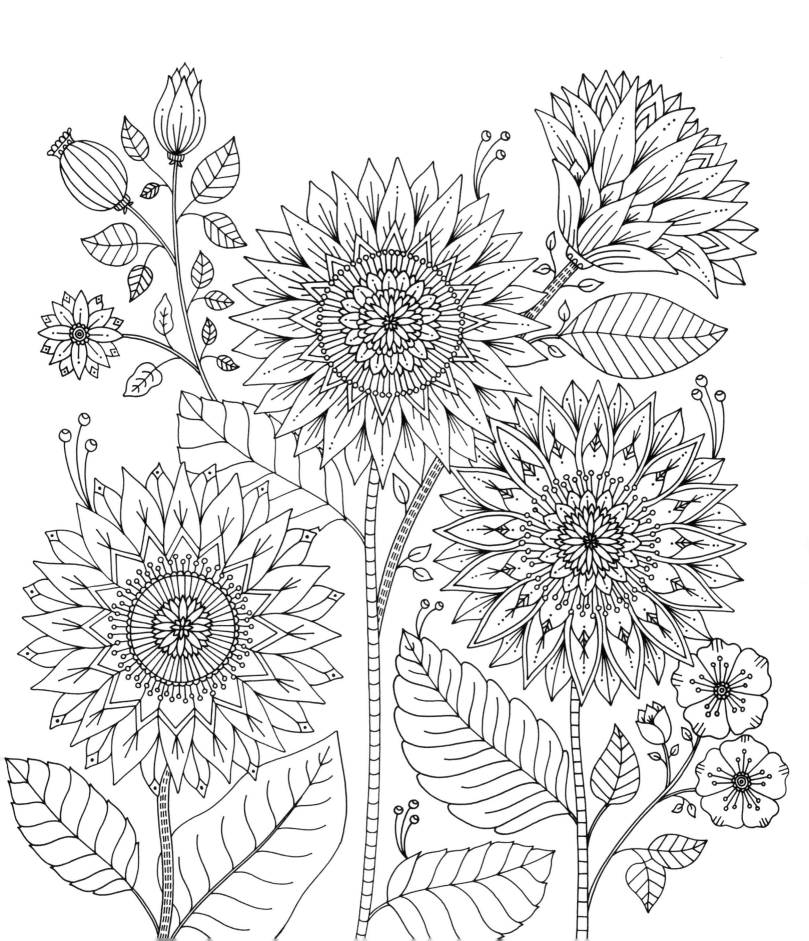

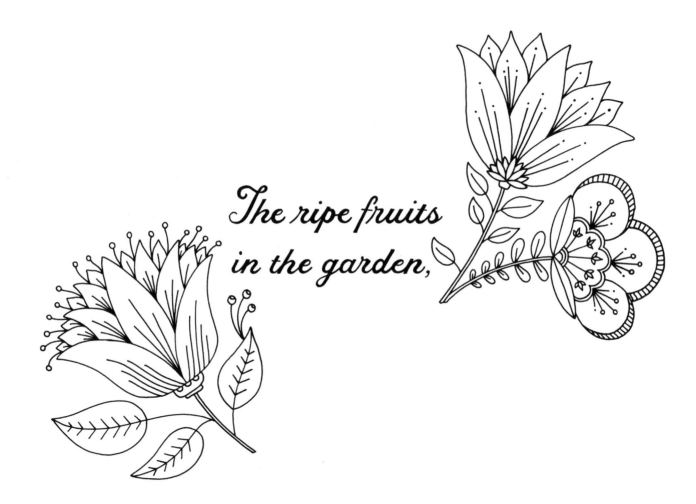

The ripe fruits
in the garden,

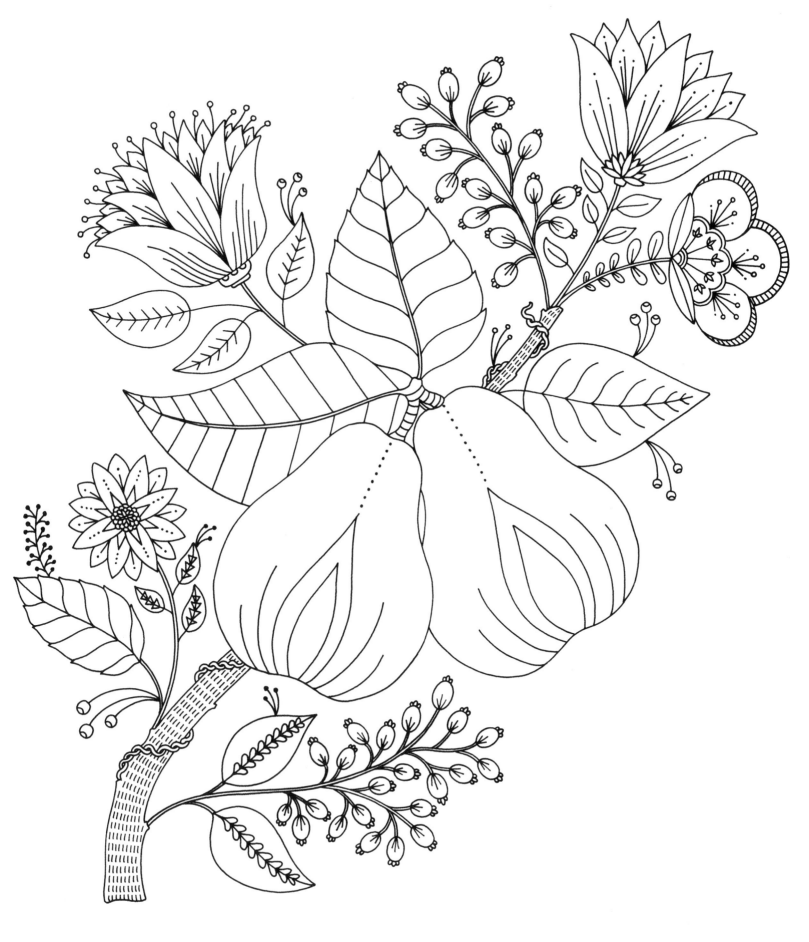

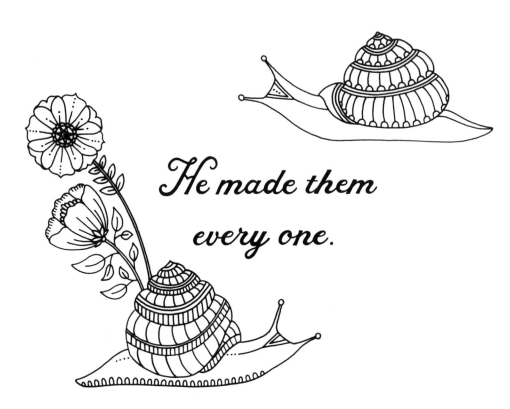

He made them
every one.

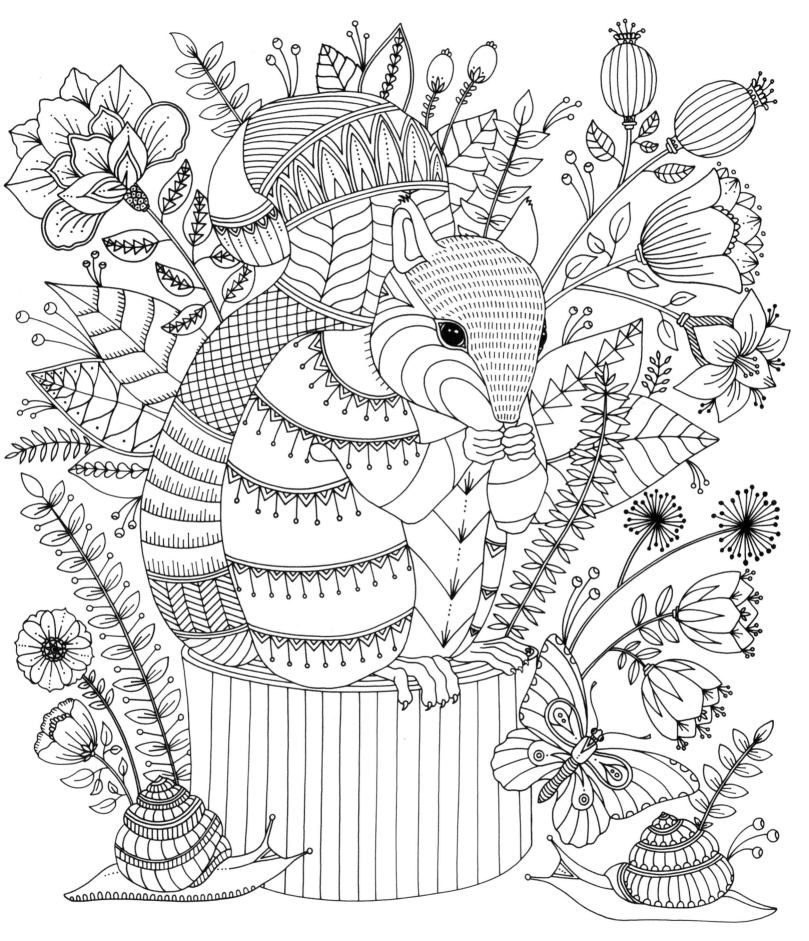

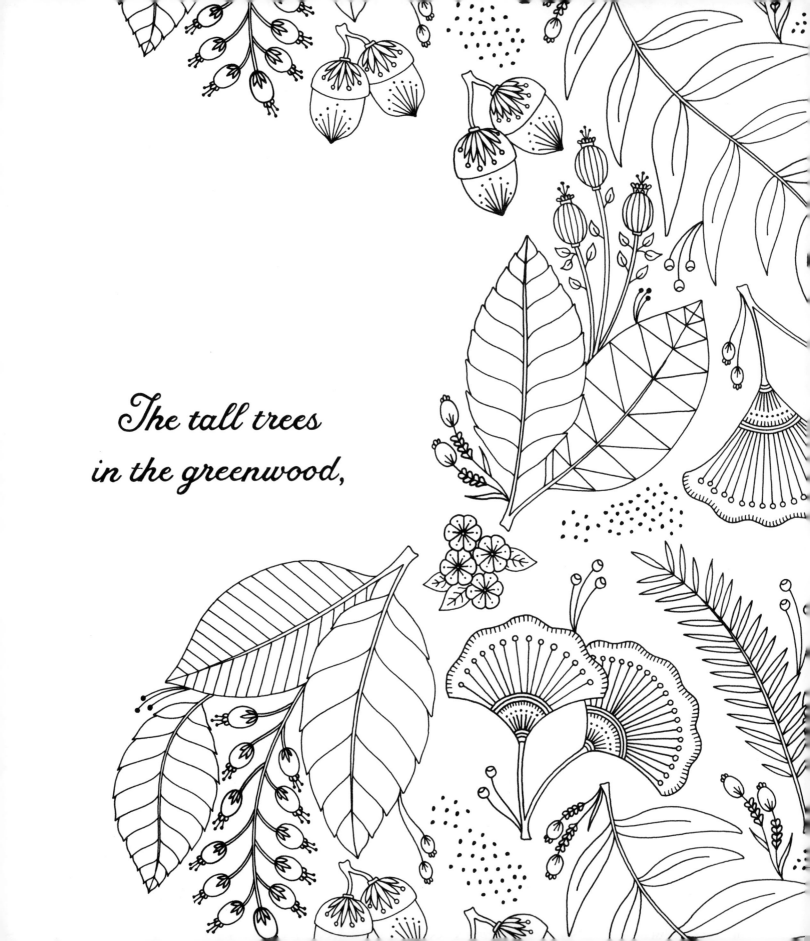

The tall trees
in the greenwood,

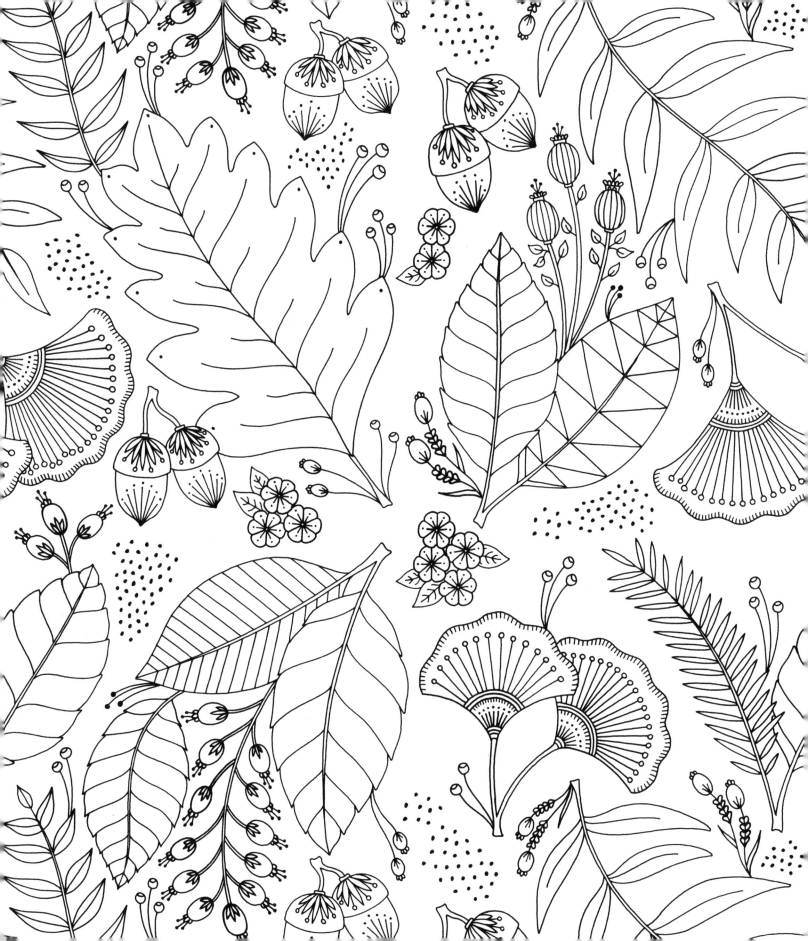

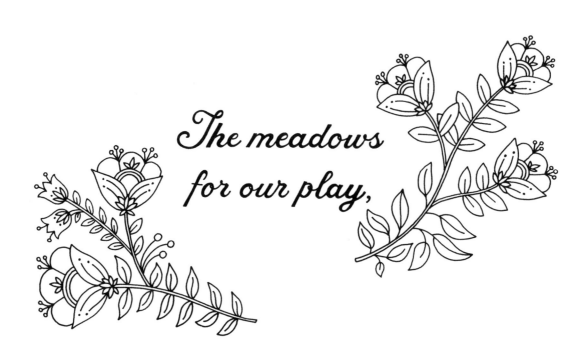

The meadows
for our play,

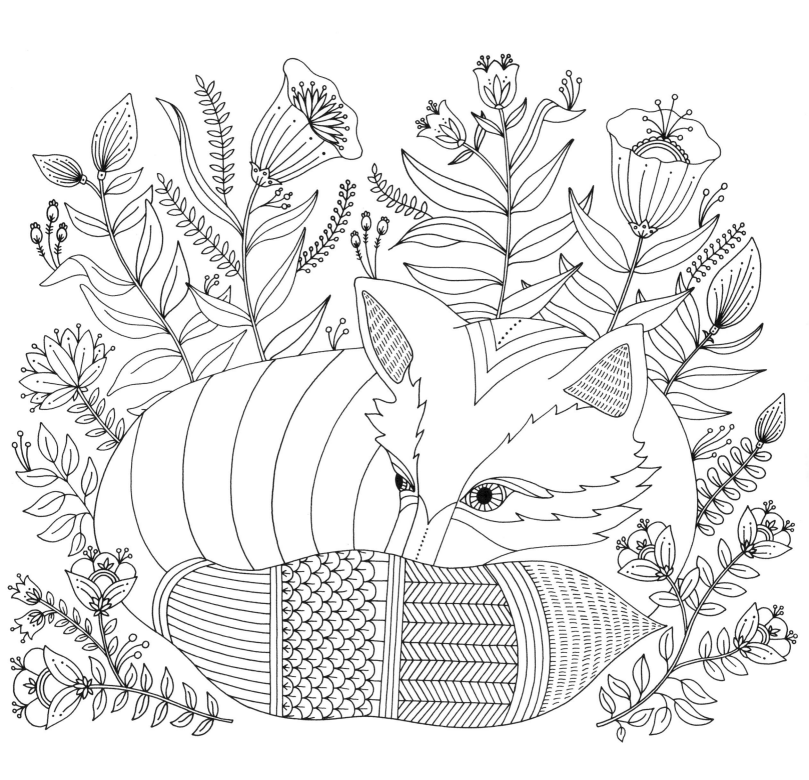

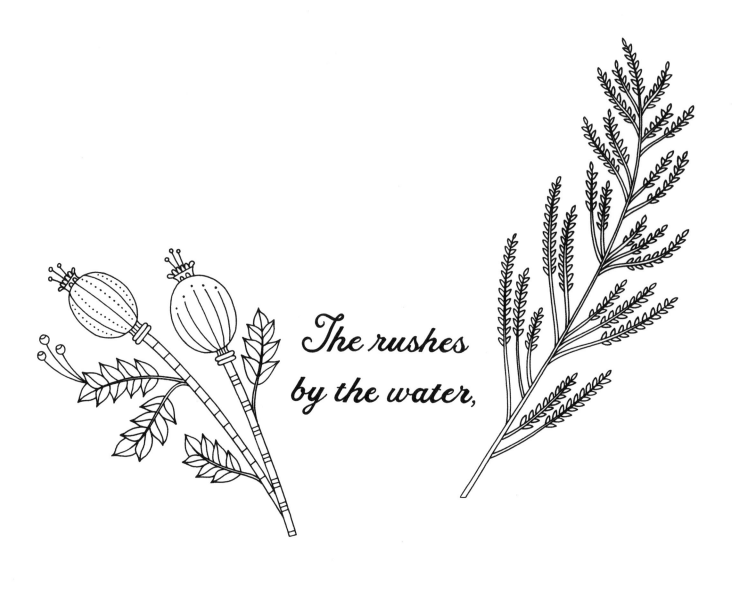

The rushes
by the water,

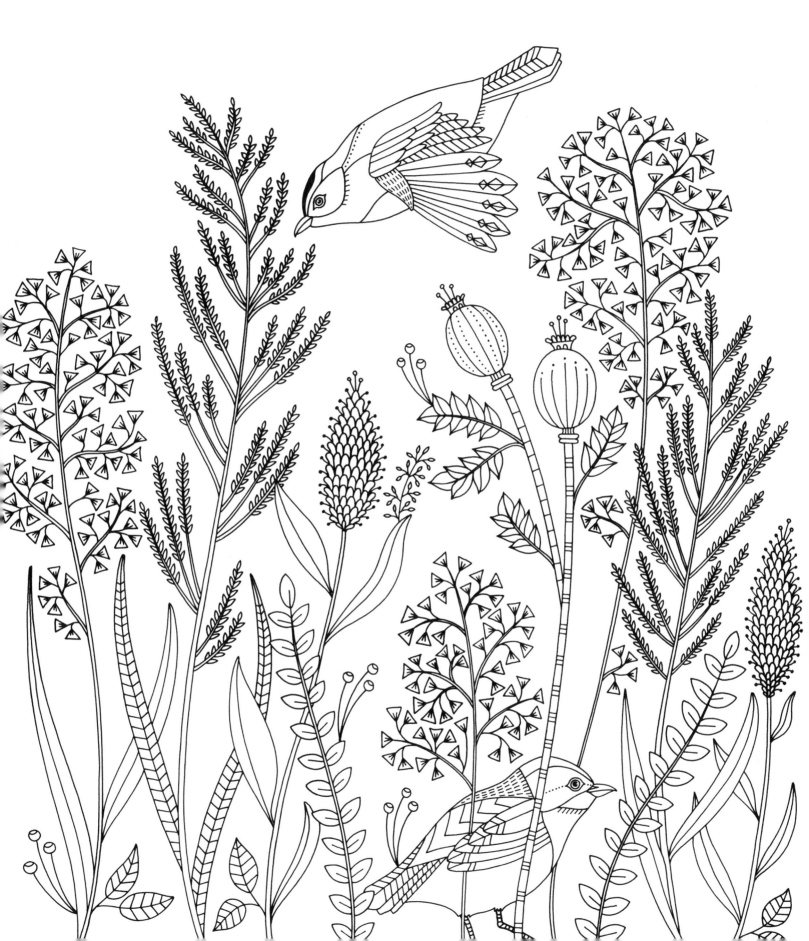

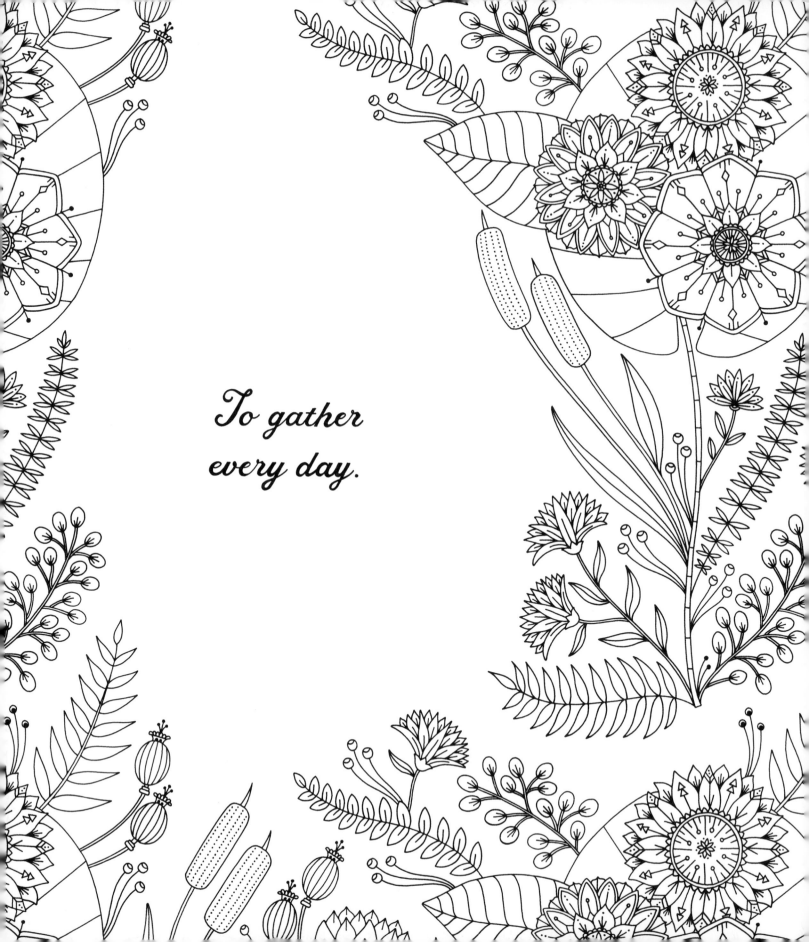

To gather
every day.

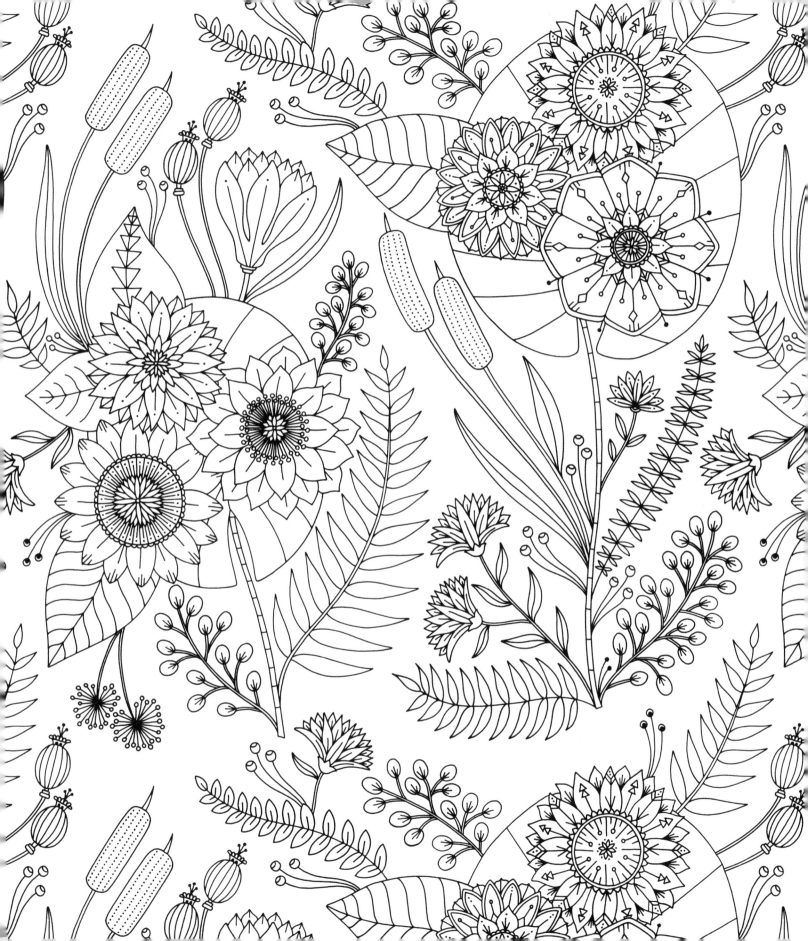

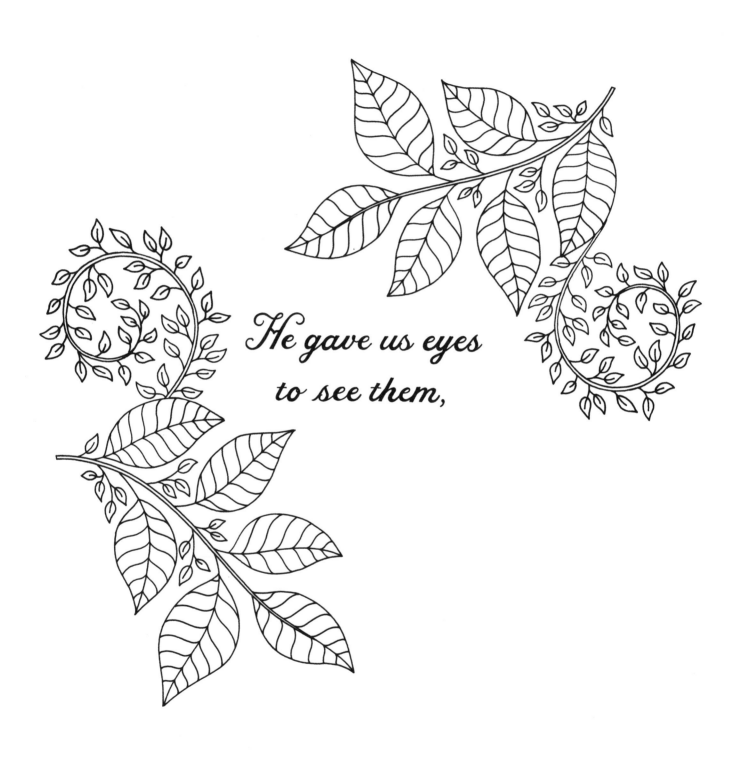

He gave us eyes
to see them,

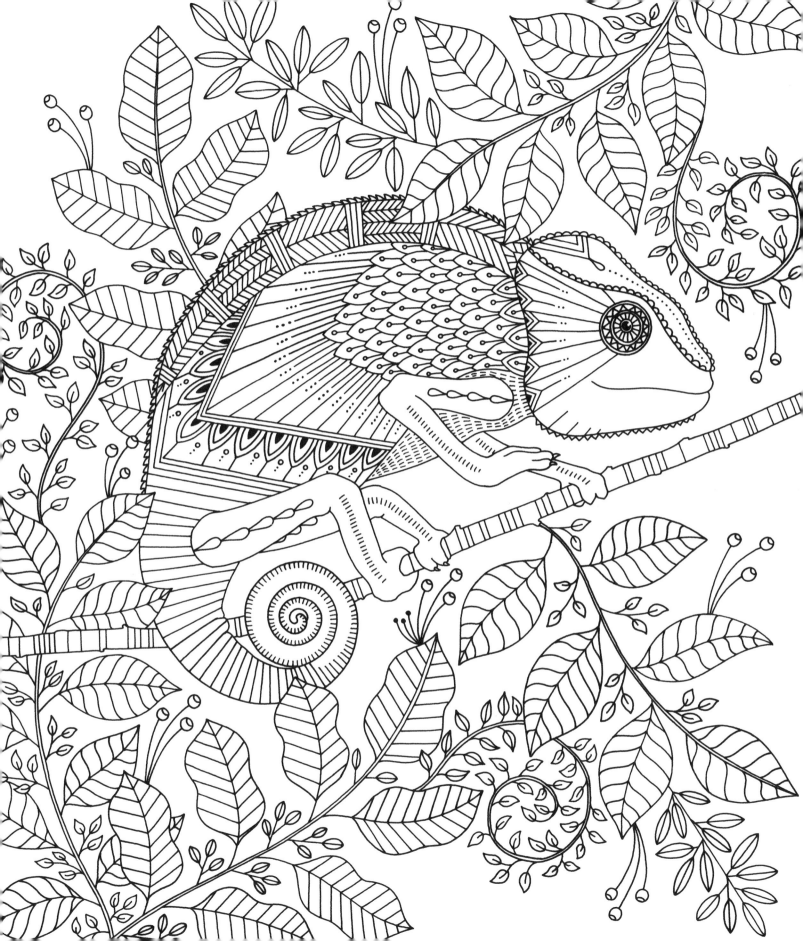

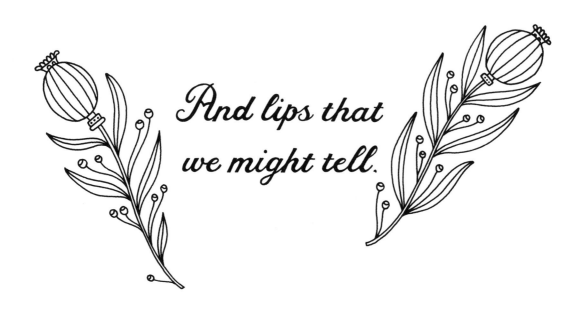

And lips that
we might tell.

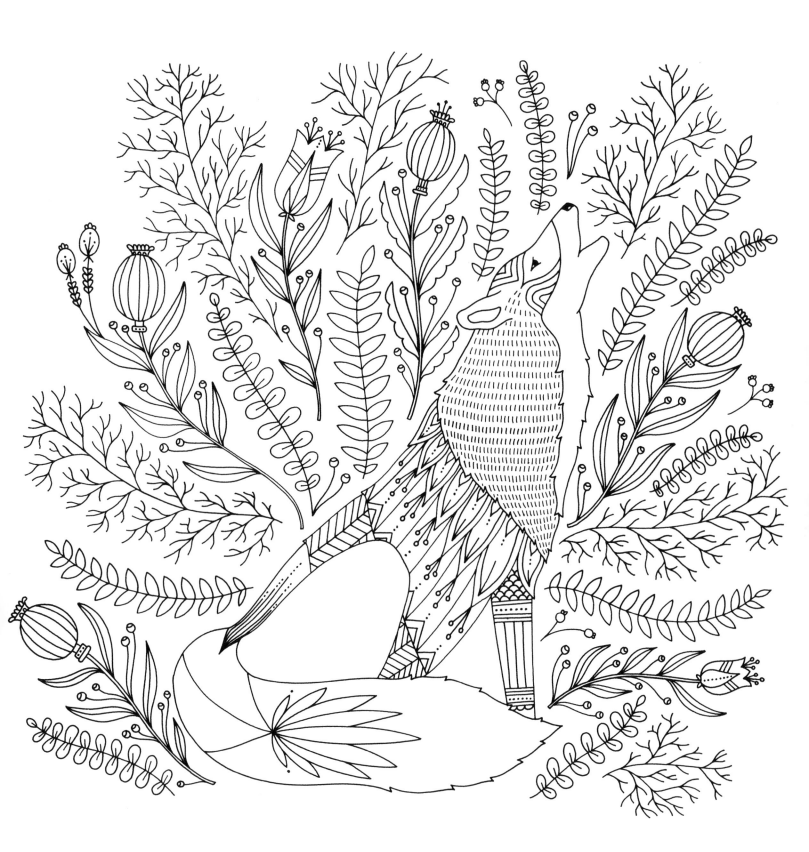

How great is
God Almighty,

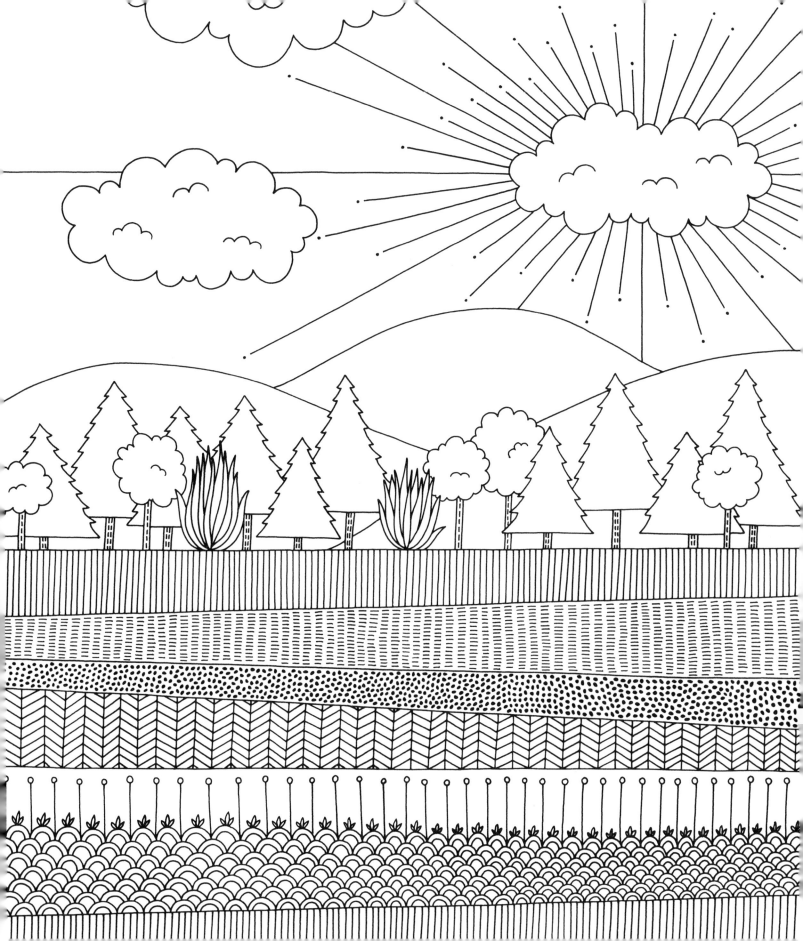

Who has made
all things well.

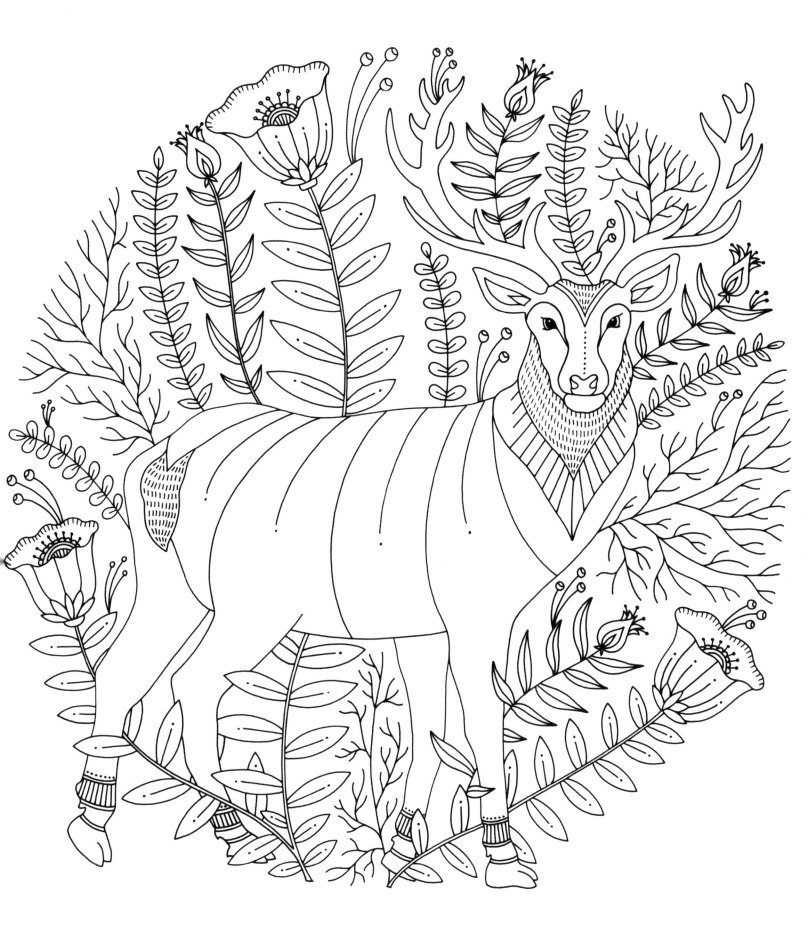

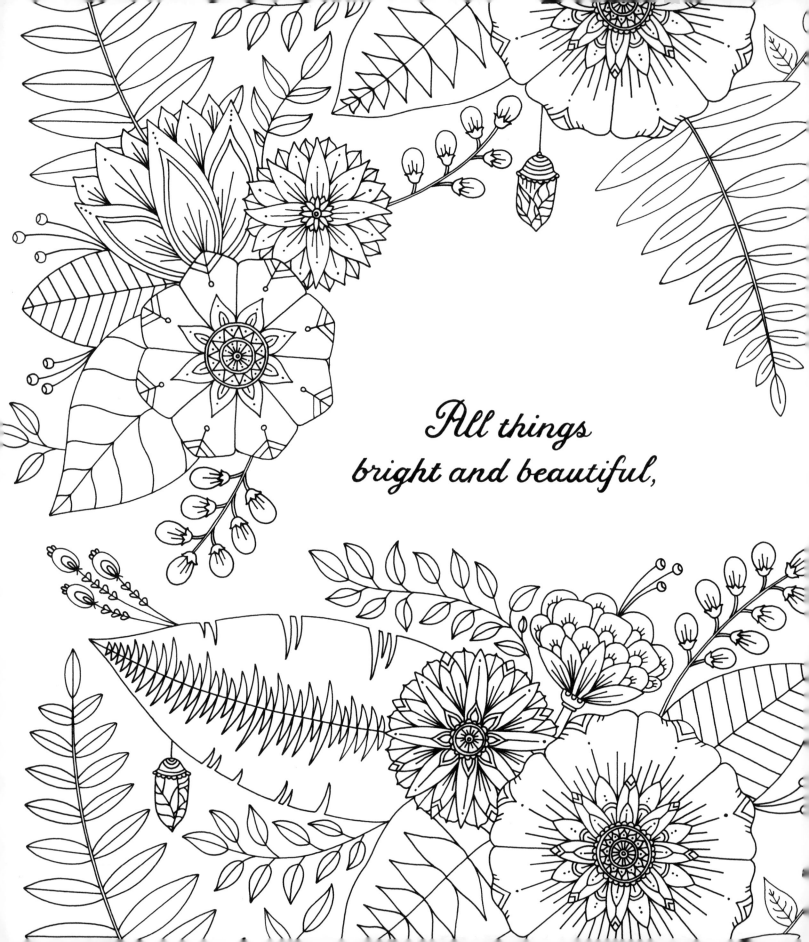

*All things
bright and beautiful,*

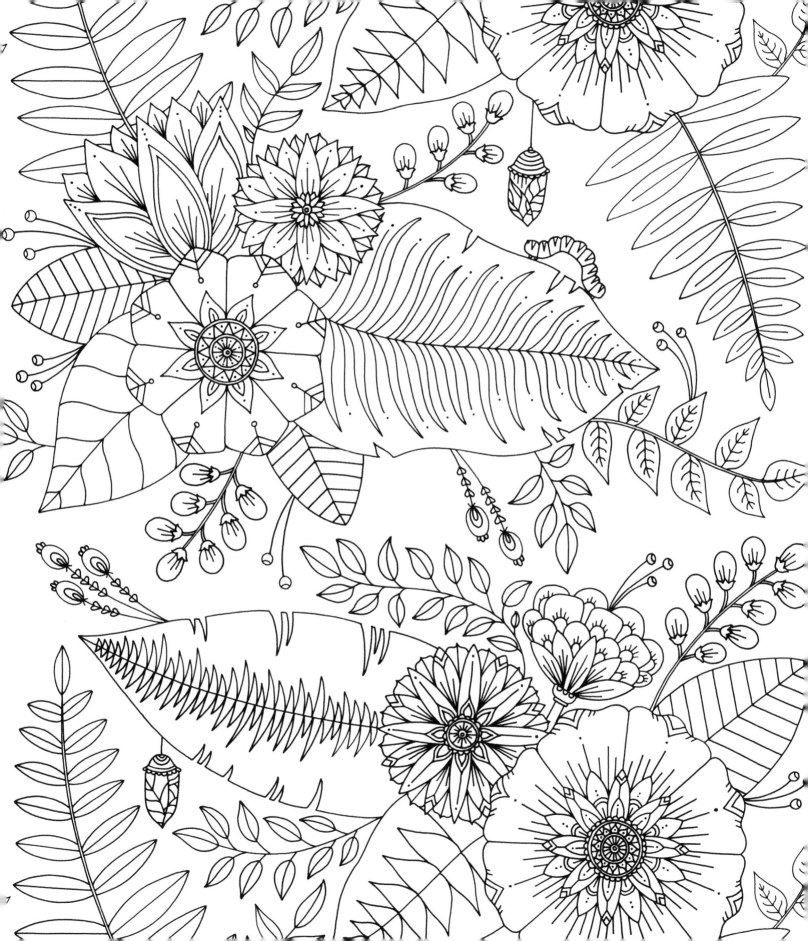

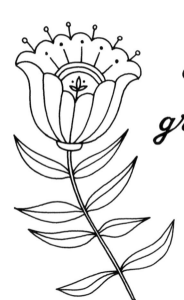

All creatures
great and small,

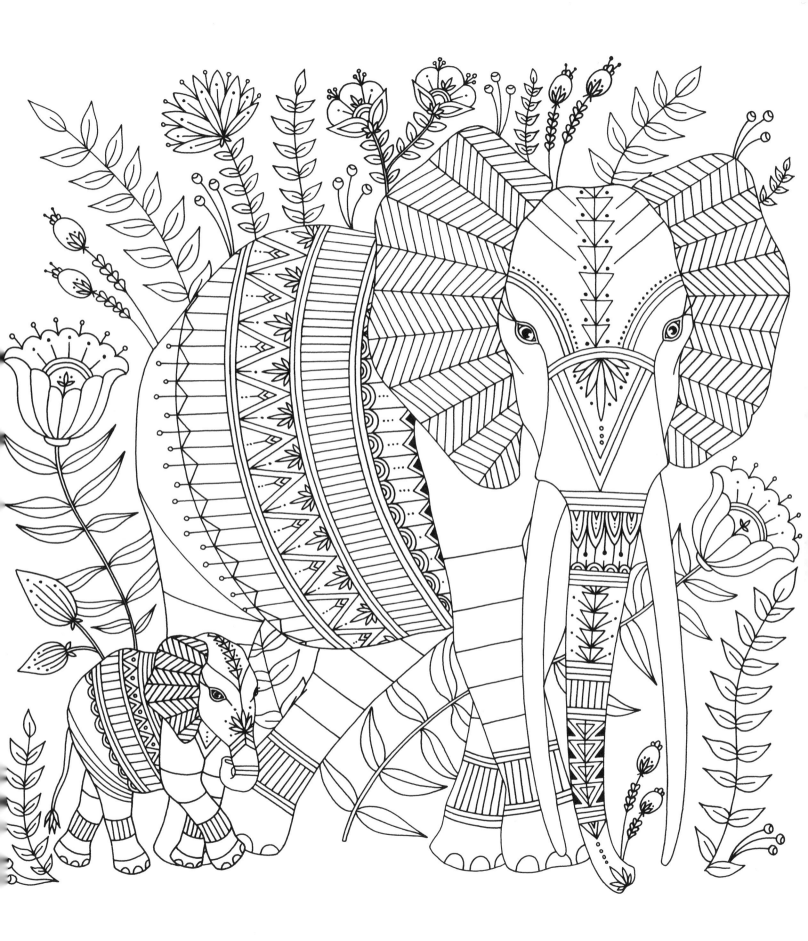

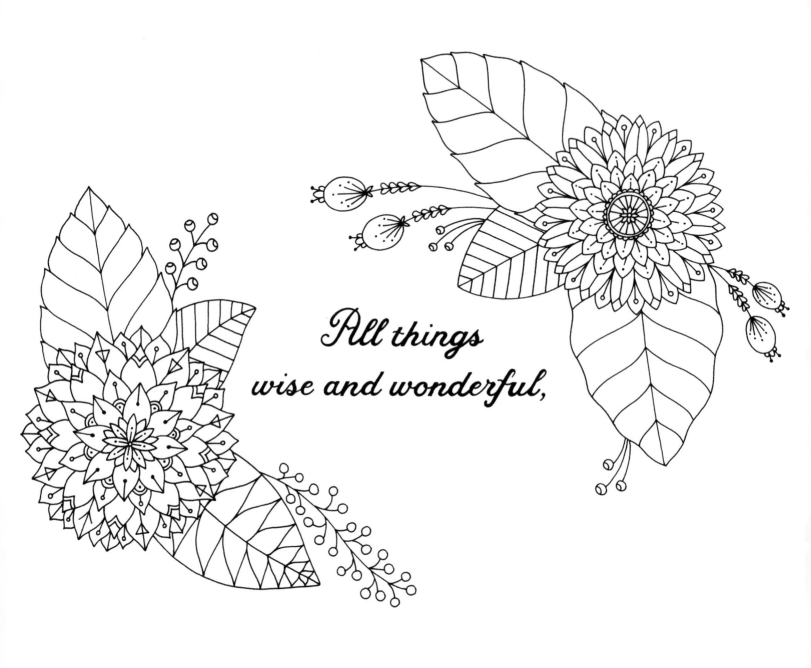

*All things
wise and wonderful,*

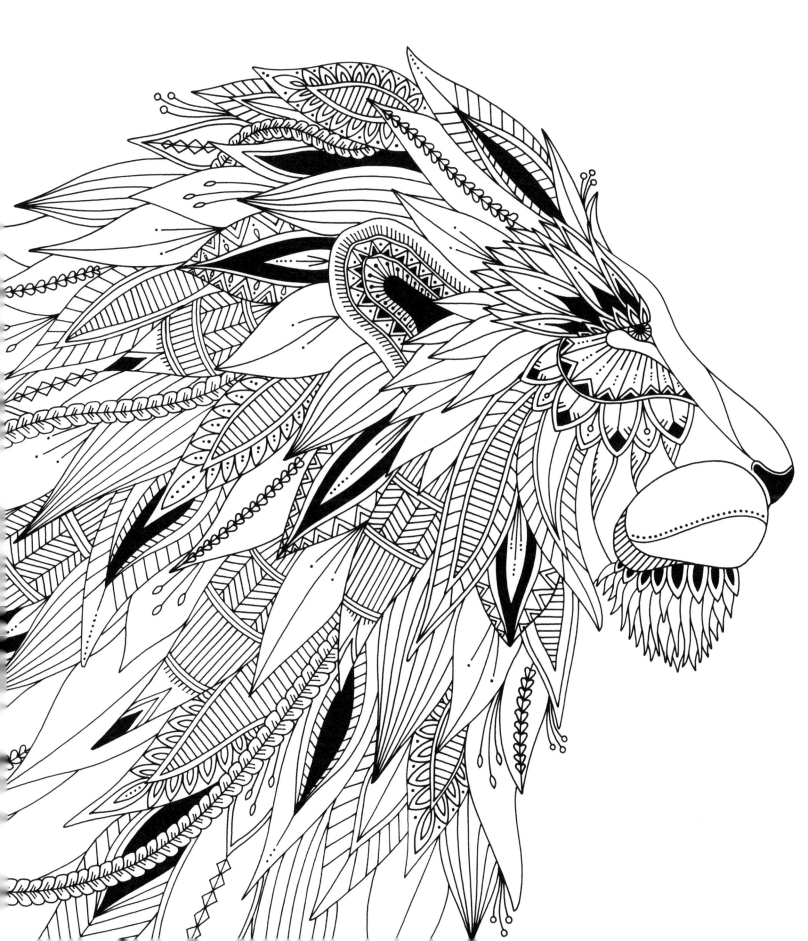

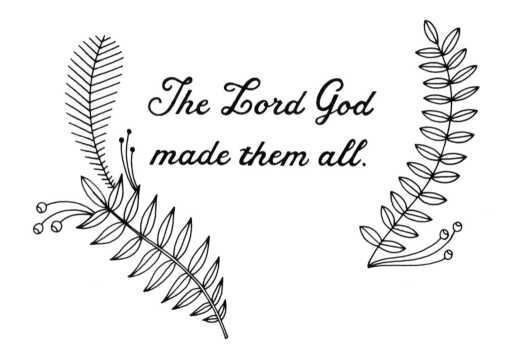

The Lord God
made them all.

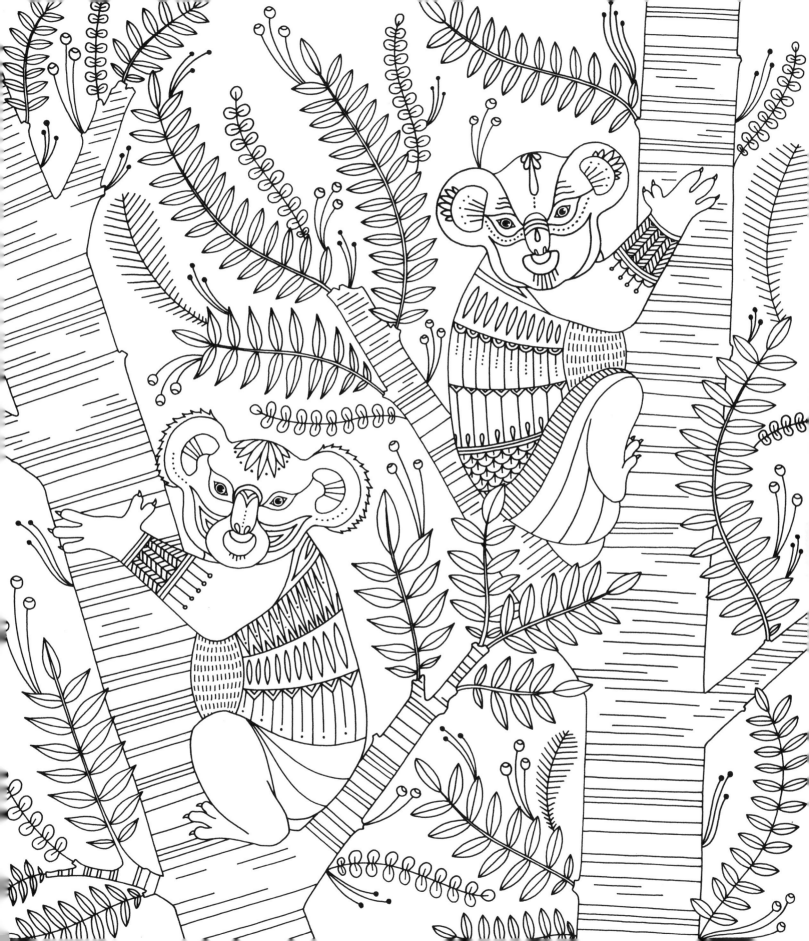

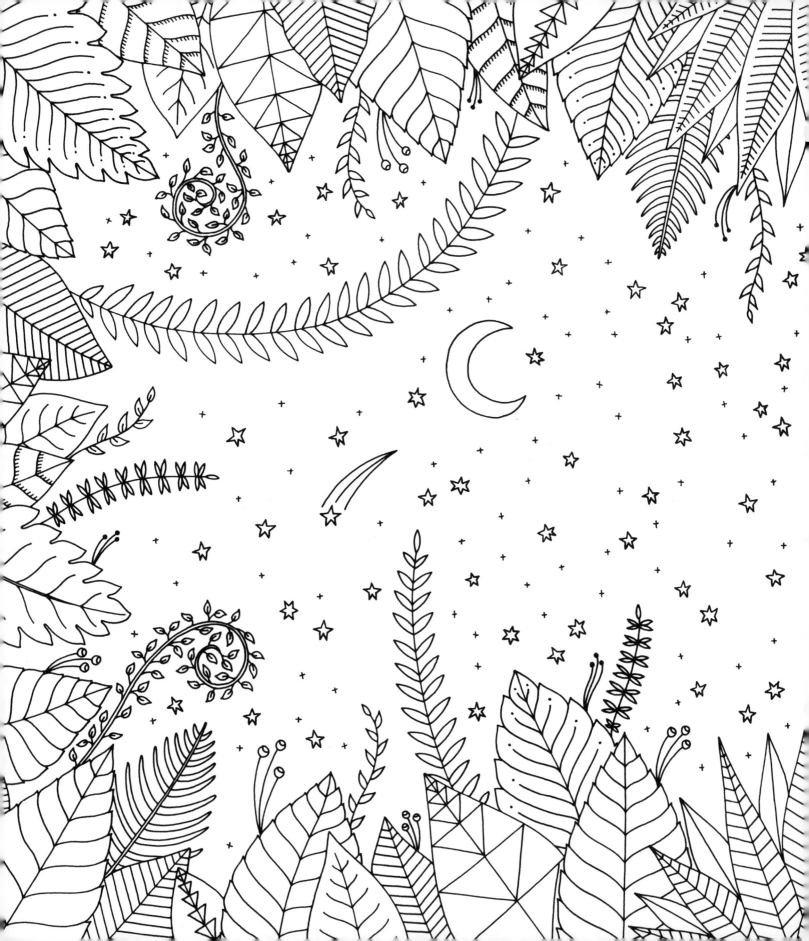

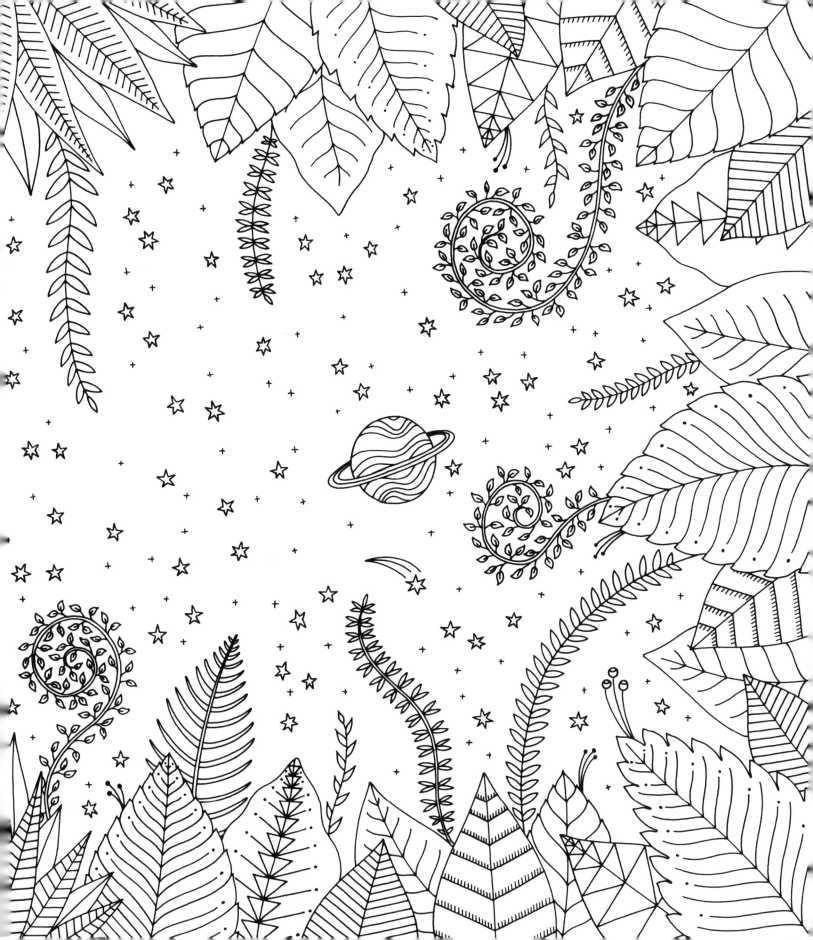

ABOUT THE AUTHOR

Cecil Frances Alexander (née Humphreys) was born in Dublin, Ireland, in 1818. She was a hymn writer, poet, and translator of French poetry. Her most celebrated work, *Hymns for Children,* which included "All Things Bright and Beautiful," was published in 1848. Her other popular hymns included "There Is a Green Hill Far Away" and "Once in Royal David's City." She died in 1895.

ABOUT THE ILLUSTRATOR

Margaret Kimball is an illustrator whose work has appeared in *Smithsonian* magazine, the *Boston Globe, Outside* magazine, *Texas Highways,* and many other places. Her first coloring book, *Birds & Botanicals,* was published in 2016. She lives with her family in Indianapolis, Indiana.